FORTY Ways to WRITE I Love You

An Hachette UK Company
www.hachette.co.uk

First published in Great Britain in 2018 by
Ilex, a division of
Octopus Publishing Group Ltd
Carmelite House
50 Victoria Embankment
London EC4Y 0DZ
www.octopusbooks.co.uk

Additional picture credits: pp. 4–5 yukipon/iStock

Distributed in the US by
Hachette Book Group
1290 Avenue of the Americas
4th and 5th Floors
New York, NY 10104

Distributed in Canada by
Canadian Manda Group
664 Annette St.
Toronto, Ontario, Canada M6S 2C8

Publisher: Roly Allen
Editorial Director: Zara Larcombe
Managing Specialist Editor: Frank Gallaugher
Editor: Francesca Leung
Researcher: Ellie Wilson
Admin Assistants: Sarah Vaughan,
Stephanie Hetherington
Art Director: Julie Weir
Designer: Ginny Zeal
Production Controller: Sarah Kulasek-Boyd

ISBN 978-1-78157-523-9

A CIP catalogue record for this book is
available from the British Library.

Printed and bound in China

10 9 8 7 6 5 4 3 2 1

FORTY ways to WRITE I Love you

LEARN AMAZING HAND-LETTERING TECHNIQUES, STYLES & IDEAS

BY LANA HUGHES

ilex

CONTENTS

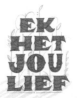

16

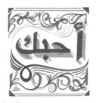

20

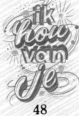

48

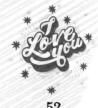

52

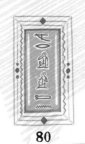

80

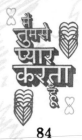

84

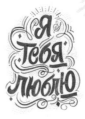

112

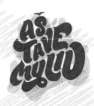

116

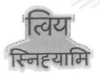

144

148

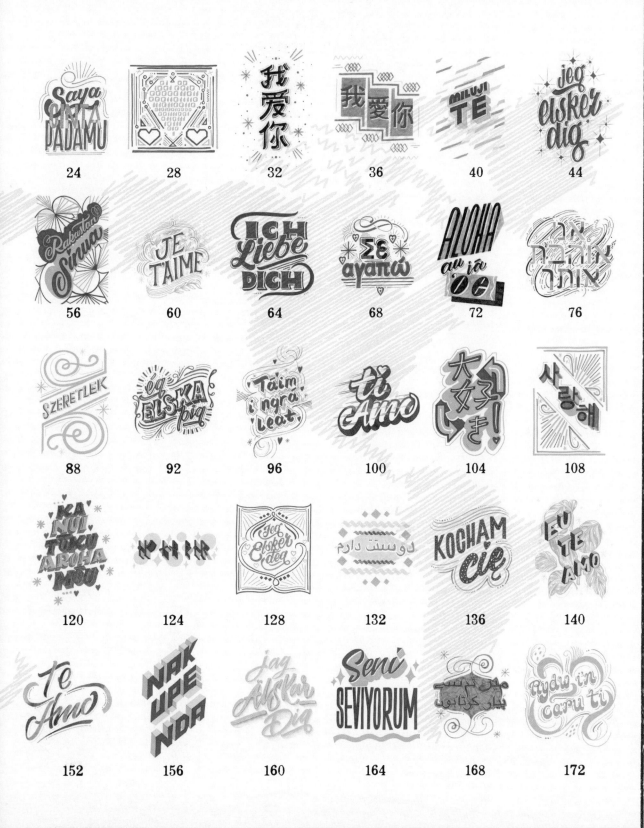

24

28

32

36

40

44

56

60

64

68

72

76

88

92

96

100

104

108

120

124

128

132

136

140

152

156

160

164

168

172

INTRODUCTION

I have always been interested in art and design – my father is a sign painter so I grew up surrounded by his signs and lettering books, and I'm sure this has played a big part in my love of lettering! I studied graphic design at the University for the Creative Arts in Farnham, UK, and co-founded a design studio called Animaux Circus with two friends, before going solo and becoming a full-time lettering artist and sign painter.

I enjoy the craft and skill involved in sign painting and love my job for many reasons, one of them being the freedom to work on my own designs and get involved in projects that I am excited by. Being a lettering artist and sign painter not only means that I get to work in my own studio, but also that I get to travel around working at a range of locations and events. Every week is different and I have the opportunity to visit new places that I might never get to see if I wasn't painting.

This book has been really fun to do, I have loved thinking about how to design messages of love in 40 languages and how to make each design fun and different. I wanted to make a book that gave you space to experiment and learn new techniques, but one that also wouldn't need you to be an expert at drawing to complete, or need you to acquire an expensive or large set of materials to recreate the examples. Every artwork in this book can be drawn using only pencil, colouring pencils, fineliner pens or felt tips – easy-to-source materials that can be found in most homes and shops.

The tutorials will get you started and give you ideas, but I hope that the book inspires you to experiment, come up with your own hand-lettering techniques and designs based on what you like, and play around with different materials and media to develop your hand-lettering further.

The possibilities are endless with lettering – have fun drawing.

LANA HUGHES

Here are some examples of my hand-lettering work to give you an idea of what's possible. You can use lettering for cards, t-shirts, tote bags, signs, anything you like – it's an incredibly versatile skill.

HOW TO USE THIS BOOK

This book is a celebration of love, highlighting the fact that all the world over, it's important to remember how valuable love is, and how as a universal feeling it transcends cultures, beliefs and even languages. But it's also fun learning how to say 'I love you' in so many different languages, and being able to tell someone what they mean to you by creating a beautiful, meaningful artwork is even better.

For each of the 40 languages in the book, there is also some background about the language itself, or on love traditions in the country the language is from. Where there is more than one way of saying 'I love you' depending on gender, all variations are given so that you can tailor your lettering to suit who you are writing to or from.

You can use this book as your very own sketchbook as there is plenty of space to practise drawing. I have designed 40 complete artworks, each based on a different language, to show what can be achieved that you can copy for practice. You can of course use different media to the ones I have used in my illustrations, and change the colour schemes as you like, or the language and words as you prefer. For each language there is also a short tutorial that gives you tips and inspiration on how to develop your hand-lettering techniques, with further room to practise.

The beauty of this book is that you should feel comfortable in picking any element of a design that you like and adapting it to your own needs, whether it's for your chosen language or style that you want to create.

WHAT YOU WILL NEED

Personally, I know when I'm excited to start creating something, I can find it a bit disappointing if I don't have the fancy materials required and have to go shopping for them first. So with that in mind, I have made it so that all you will need to recreate my examples in this book are things that you will likely have already:

- ♥ A graphite pencil
- ♥ A pack of colouring pencils
- ♥ A range of fine-liner drawing pens
- ♥ A pack of felt-tip pens

And if you don't have these to hand, the great thing is that they are easy to pick up from almost any shop – these items can be found at most supermarkets and even newsagents.

Graphite pencil: A plain pencil can be used to create a range of effects, from light hair-like lines to heavy thick lines. You can also use pencil for shading with the side of the lead or by pressing the lead down hard on the paper for a deep black block colour.

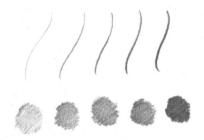

You can achieve different shades depending on the amount of pressure you put on the pencil.

Gradients are an easy and fun pencil effect – simply start off pressing the pencil down hard on the paper and reduce the pressure as you shade.

Colouring pencils: Much the same as with a graphite pencil, you can achieve gradients and effects by varying the amount of pressure you apply on the paper. However, because you can play around with a range of colour combinations, rather than just the shades of grey you would be limited to with a graphite pencil, these allow for a much wider range of pattern and design options.

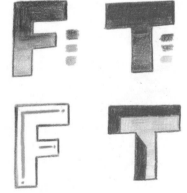

Fine-liner pens: These pens are good for colouring and highlighting small areas, as well as outlining shapes and adding detail.

Felt-tip pens: These are great for when you want a very bright and vibrant look for your artwork, as their colours really pop from the page. They are available with all manner of thicknesses of tip and colours so you can choose the best ones to suit your purposes, whether that's shading block colour, outlining or adding detail.

Other materials: There is plenty of space for you to sketch in this book, but you might also want to invest in another sketchbook for further experiments when you are finished - although really any paper will do if you want to draw more! It can also be useful to have some graph paper if you want to practise getting proportions right, or for when you are planning out a more intricate design. If the style of lettering you are drawing requires more accuracy, it is also good to have a ruler handy for measurements and drawing straight lines. You may also find it useful to have an eraser for when you make mistakes.

LETTERING TERMS/ GLOSSARY

In lettering and typography, there are several terms used to describe different styles and elements of design. Here are some of the most common for your reference, which you might want to experiment with in your work.

SERIF: This means that the letter features a small extension at the end of the main strokes. Serifs appear both horizontally and vertically on letter-forms and can be seen on typefaces such as Times New Roman, Baskerville and Didot, to name a few.

SANS SERIF: The word 'sans' is a French word meaning 'without', so this translates literally as letters 'without serif'. Some examples of sans serif typefaces are Helvetica, Futura and Avenir.

SCRIPT: A script is lettering that involves a more joined up, flowing style rather than a more uniform, regular style. It is very clearly handwritten, or emulates handwriting in the case of printed scripts. Examples of script typefaces include Brush Script, French Script and Lucida Calligraphy.

UPPER/ LOWERCASE: These are simply the names used to describe the size of the letter you are using, uppercase letters are in capitals, and lowercase letters are their smaller versions.

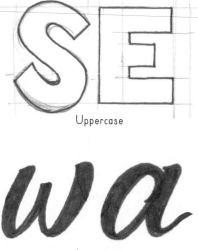

Uppercase

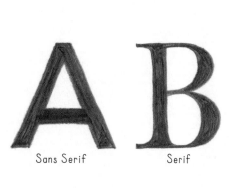

Sans Serif Serif

Lowercase

ASCENDERS/ DESCENDERS: Lowercase letters have what are known as ascenders and descenders that extend above or below the main height (x-height) of the letters. For example if you look at a lowercase h or d, you can see the top part of the letterforms extend above the main portion of the letter; these are ascenders. Descenders are much the same, except they are the parts of lowercase letters that fall below the main section of the letterform and can be seen on the letters y, g or p.

TRACKING: This is also known as letter-spacing and refers to the amount of space that lies between the letters in a word or sentence. It is important to get tracking right for legibility and design purposes.

When letters are too close together or overlapping each other, this can make them difficult to read and they look messy and squashed. But when letters are set too far apart, this can look very odd and make it hard to read where one word begins and the next one starts.

LEADING: This is the space between lines of text and is also known as line spacing. Having overly large leading can make words difficult to read if they are stacked on top of each other, especially when they are meant to be connected as a phrase or sentence. Similarly if the leading is too small, the letters don't have enough room to breathe and can look cramped.

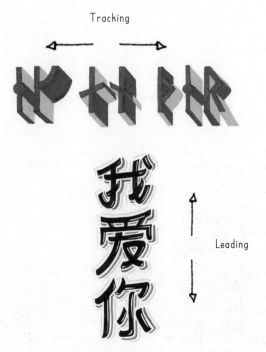

Tracking

Leading

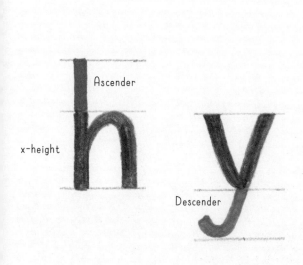

Ascender

x-height

Descender

INSPIRATION/ IDEAS

Often I like to take a look at what other designers have been up to, have a quick read about what's new in the creative industry and of course simply admire other artists' work! It's a good way to get inspiration for your own artwork and see how your style compares to what else is out there.

ONLINE RESOURCES: Instagram and Pinterest are obvious examples of places to find inspiration online, but I also particularly like Behance, It's Nice That, Colossal, People of Print, Better Letters, The Pre-Vinylite Society, Typism, The Design Tip, Creative Review, Friends of Type, Cool Hunting, designboom and FormFiftyFive.

FAVOURITE ARTISTS AND DESIGNERS: There are so many amazing artists and designers around the world that I love and admire, and I would definitely recommend checking out Louise Fili, Nick Misani, Luca Barcellona, Jake Rainis, Matthew Tapia, Lauren Hom, Martina Flor, Gemma O'Brien, Alex May Hughes, Mike Meyer, DABSMYLA, David A Smith, frankandmimi, Tristan Kerr, Ornamental Conifer and Gary MSK, to name but a few.

MUSEUMS AND GALLERIES: Wherever you might be in the world, there is bound to be a museum, gallery, exhibition or creative event near you that you can visit. Here are just some of my favourite places around where I am based in London, and that I have visited on my travels:

- ♥ London, UK: Tate Modern, Barbican Centre, Design Museum, Serpentine Galleries, Hang-Up Gallery, NOW Gallery, Jealous Gallery
- ♥ Sydney, Australia: Art Gallery of New South Wales, The Museum of Contemporary Art Australia, White Rabbit Gallery Sydney, aMBUSH Gallery
- ♥ Barcelona, Spain: Museu Picasso
- ♥ Naoshima, Teshima and Inujima, Japan: Benesse Art Site Naoshima
- ♥ Ho Chi Minh City, Vietnam: Station 3A, Museum of Fine Arts

Most people have a camera-phone to hand all the time nowadays, so it's easy to build up a collection of photographs you like that you can refer to for your work. Whether you're travelling, or simply

out and about, if you make a habit of photographing things that inspire you it will help when it comes to generating new ideas as the photographs will act as image references.

Inspiration is everywhere and you never know when you might stumble upon something that triggers a new idea for you. Things I tend to photograph are: shop signs, neon and window signage, funny or misspelled signs, patterns in plants and shadows, street art and patterns in architecture. The more you look the more you will understand how things like shapes and shadows work in designs.

Here is a selection of photo inspirations that I have collected myself to give you an idea of what to include for your own image library!

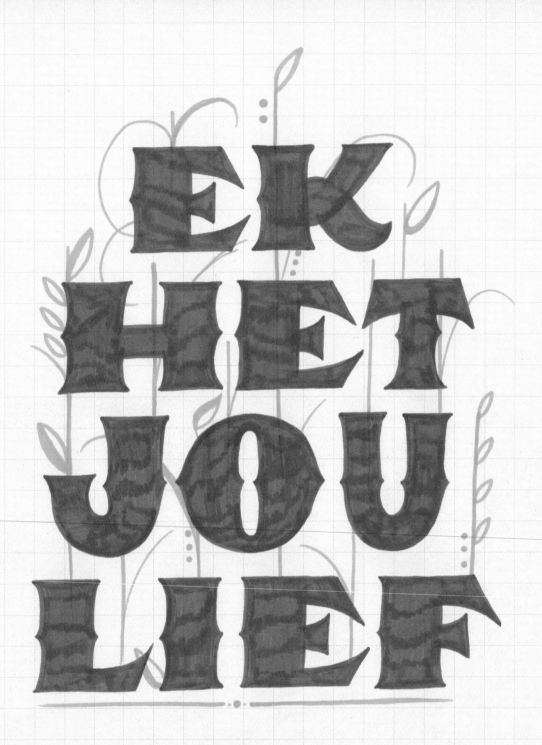

AFRIKAANS

EK HET JOU LIEF

Afrikaans is one of the 11 official languages of South Africa and derives from Dutch, which is estimated to make up around 90 per cent of the origins of Afrikaans vocabulary.

There are many possibilities for how you can decorate letters and here are just some examples of different ways that you can fill the space within their outlines. You could add small images or patterns, or simply fill them using a colour, leaving a thin border all around. Try some examples for yourself.

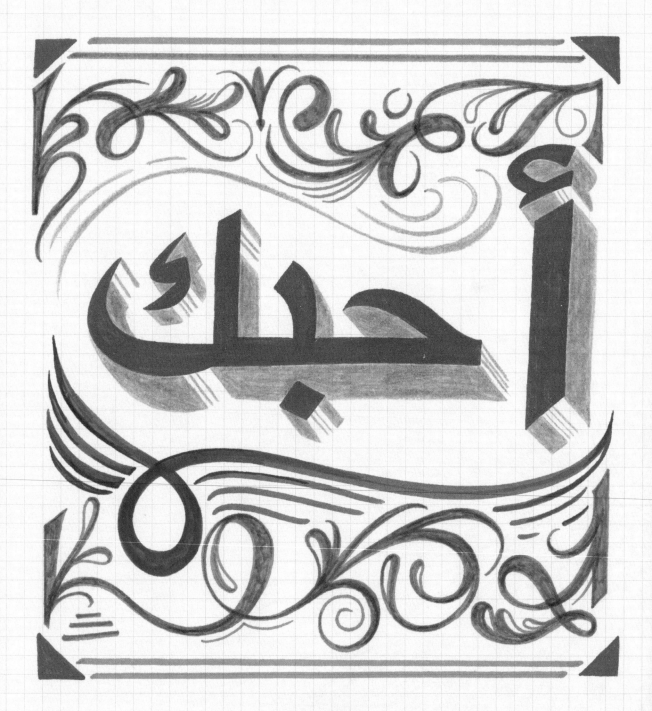

ARABIC

AHUBBUKA (to a male)
AHUBBUKI (to a female)
Arabic has more than 11 words for love, the most common, 'hubb', as used for this example of 'I love you',
is the love between lovers, or children and their parents, but not between friends. The phrase differs depending
on if you are addressing a male or female, but the writing is the same for both.

ARABIC

You can develop more complex patterns to apply to
your lettering. Look for patterns that you like from
photographs or by researching online and in books,
and use them to inspire your own drawn designs.

You can then use the pattern you have designed for
individual letters or across a whole word or sentence.

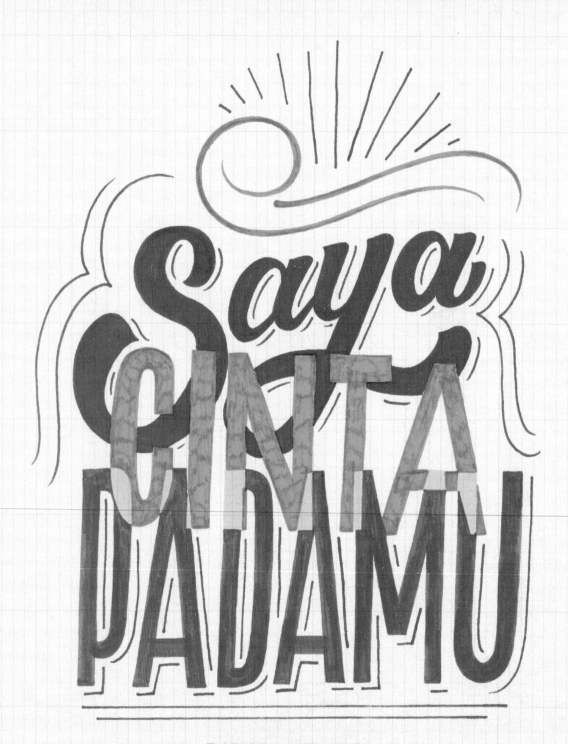

BAHASA MELAYU

SAYA CINTA PADAMU

Bahasa melayu is the national language of Malaysia. It includes words borrowed from a range of other languages, such as Sanskrit, Tamil, Persian, Portuguese, Dutch, Chinese, English and Arabic.

Although it's often important to leave enough room for letters to breathe (see tracking and leading on page 13), you can also play around with decreasing the space between letters so that they overlap each other to create unusual effects.

For example, you can colour overlapping letters in a way that creates a typographic illusion of depth and looks as if letters are woven in and out of each other. Start by sketching out a row of letters and then experiment with drawing another row of letters on top so that it partially overlaps the first row.

You will see that the areas that overlap create new shapes. These can be shaded in with a new colour to highlight the overlapping effect, but use this overlapping technique sparingly - it doesn't work well when there is a lot of text as it can make it hard to read.

BINARY (ASCII CODE)

01001001 00100000 01101100 01101111 01110110
01100101 00100000 01111001 01101111 01110101

Even computers can be romantic! The binary ASCII code allocates each alphabetical character a distinct pattern of 0s and 1s, so when writing 'I love you' in English, a capital 'I' is '01001001', the following '00100000' is code for a space and so on. Binary is considered a universal language; NASA has even used it to broadcast a message into space for intelligent life!

BINARY (ASCII CODE)

It can be fun to experiment with how far you can change a letter or character but still have it be recognizable for what it is. The trick is that there should be enough detail to be able to recognize it, but the style will look quite different just by adding a small design feature, such as adding a square to this O here:

And for this number 1, I have given it a tail with a pattern like a shooting star, but maybe if you didn't know it was a 1 you would have trouble guessing!

Try adding details to some numbers, letters or shapes yourself to create new morphed characters and combining them with patterns to see what lettering designs you can come up with.

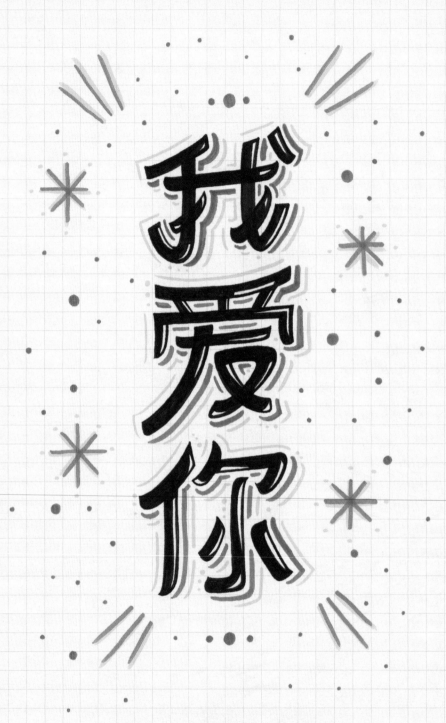

CHINESE (SIMPLIFIED)

WO AI NI

Simplified Chinese characters, instead of their traditional versions, are used mainly in China and Singapore. There are more than 50,000 Chinese characters but in daily life you only need to know roughly 3,000 to read things like Chinese newspapers.

You can make use of shadows, highlights and shine to make your lettering look 3D and to make it stand out.

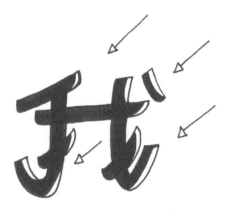

When adding shadows, highlights or shine to lettering, consider where the light source is meant to be coming from, so that you can be consistent throughout the design.

Anything that would be hidden from the light source would be in shadow, and anywhere that the light would hit would be highlighted, and is where it would shine.

Practise adding shadows, highlights and shine here, and on your own lettering.

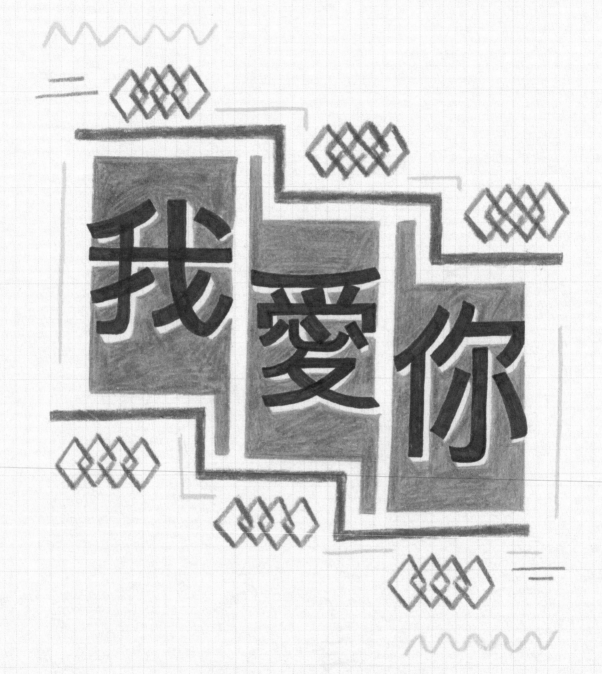

CHINESE (TRADITIONAL)

WO AI NI

Of all languages living today, Chinese is the oldest written language in the world, and is traditionally written from top to bottom in columns from right to left across the page. Nowadays, it is also common to see text written in rows from left to right in the Western style (as in the example here). In Hong Kong, Macau and Taiwan, traditional Chinese characters are still more prevalent than their simplified versions.

You might also want to design a frame around your lettering as part of the design. It could be any shape you like, such as a flag, a heart or a square.

Why not try leaving a border around a word or letter, and then shading in a shape around it to make it stand out?

Or drawing some diagonal lines to make a striped pattern that acts as a frame surrounding the word?

If you're adding in the frame as a background after you've drawn your lettering, it can help if you draw a border around the lettering lightly in pencil first. This is so that you know where to colour in or draw the background pattern up to, to leave a border around the lettering so that it stays clear. And you can just erase the light pencil guideline afterwards.

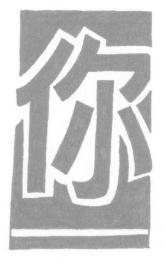

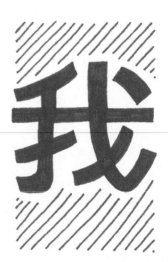

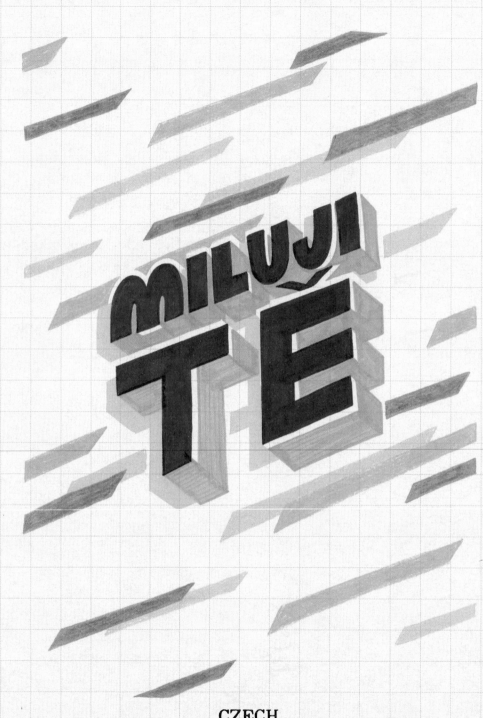

CZECH

MILUJI TĚ

Say 'miluji tě' with a gift of a bouquet to symbolize true love — in the Czech Republic, flowers and their colours have different meanings, known as 'květomluva', 'the language of flowers'.

With this technique, inspired by bright neon signs with lots of lightbulbs, try adding some circles inside letters and then lines radiating outwards to make them look like they are flashing on the page. You can do this with 2D and 3D lettering, and the brighter the colours you use the better – you want the text to shout!

DANISH

JEG ELSKER DIG

Purportedly one of the happiest countries in the world, it is customary in Denmark to practise 'hygge',
the act of appreciating life's simple pleasures and feeling cosy. It often involves gathering by candlelight — a perfect
time to whisper 'jeg elsker dig' to a loved one.

Choosing complementary colours for your lettering
will give the design a particularly unified feel where
it looks like everything works smoothly together.

Colours that complement each other sit next to each
other on a colour wheel, so blues with greens, greens
with yellows, yellows with oranges, oranges with reds,
reds with purples, purples with blues.

Try adding stripes, dots or highlights and shadows
to these letters using complementary colours to see
how they look.

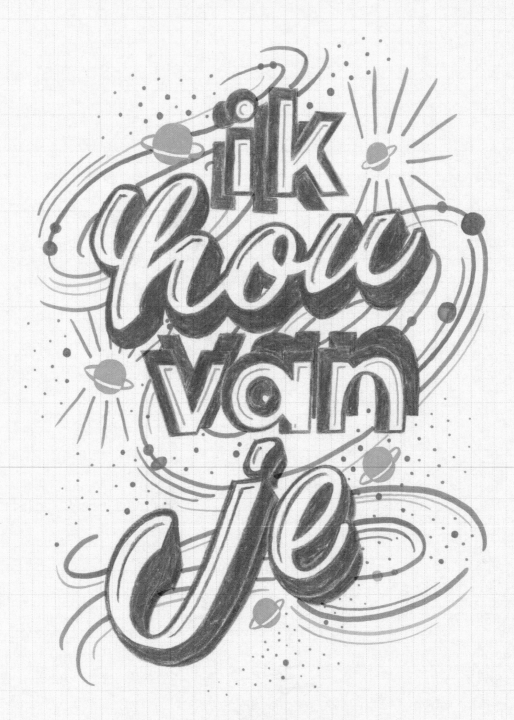

DUTCH

IK HOU VAN JE

Dutch is the predominately spoken language in the Netherlands and Belgium. Dutch people often kiss when they meet, sometimes up to three times depending on local custom.

Drop shadows can be used to create the illusion that your letters are floating from the page. They can be created by drawing your lettering, then making a copy that overlaps diagonally with the original letters. If you do this construction lightly in pencil, you can erase any guidelines when you have finalized your design.

The arrows show the rough distance the shadow should be away from the letters... the further back the shadow is, the higher the letters appear to be floating. But be careful not to have the shadow too far away from the letters, they should always be overlapping, otherwise they start to look disconnected.

This letter shows a shadow that is filled, and a simple outlined letter in the foreground.

... And here is the opposite, a shaded-in letter with an outlined shadow.

Try adding drop shadows to some letters for yourself to see how you can use the technique to add emphasis, and make your lettering stand out!

ENGLISH

I LOVE YOU

English has become the global lingua franca for communication between people without a shared native language, and is the most widely learned second language in the world. It is also one of the most diverse languages, with more than 250,000 distinct words in its vocabulary.

You can use anything as a background pattern for your lettering – dots, flowers, stripes or anything else that you can think of!

If you do use a patterned background though, leave your lettering in one block colour – having both patterned lettering and a patterned background can be difficult to read.

Practise adding patterned backgrounds to these letters for yourself.

PRACTISE HERE

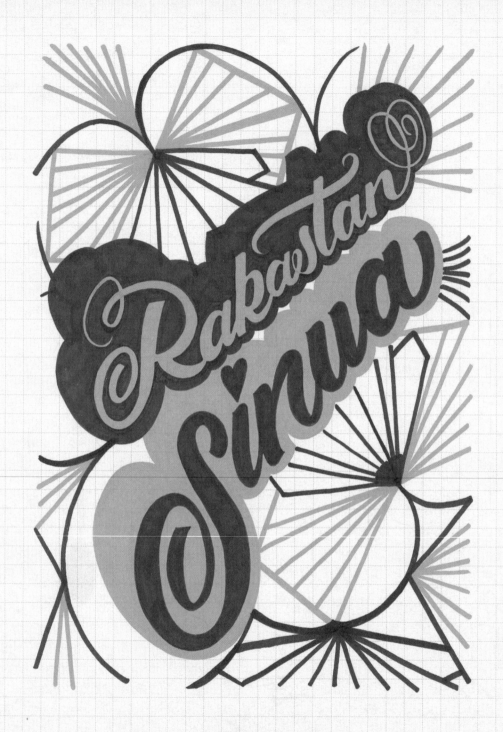

FINNISH

RAKASTAN SINUA

When saying 'I love you' in Finnish, save it for a very, very special occasion – the phrase is rarely used as it's considered too weighty for most situations. You might want to try 'rakas' instead as a term of endearment to call someone 'dear'.

Adding flourishes to cursive (joined up) lettering
is a great way to create a beautiful, decorative
style. Flourishes can also be layered around
letters as added details or as a border.

Try adding some curly lines, swooshes and
swirls to the practice letters here and to
your own hand-lettering.

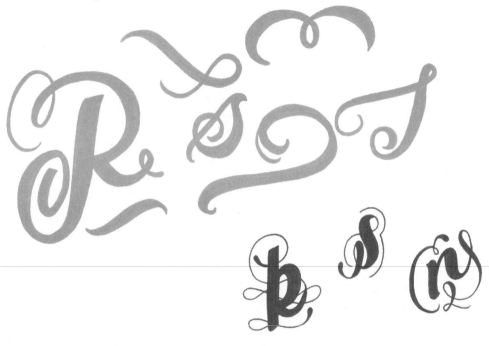

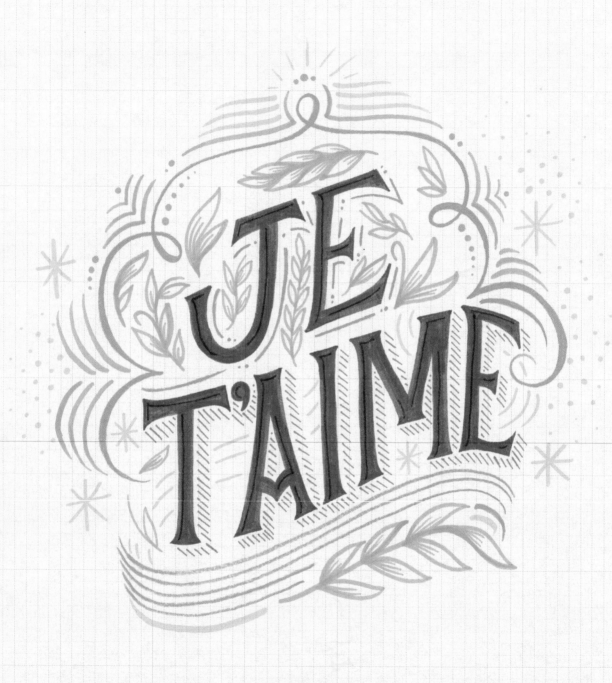

FRENCH

JE T'AIME

Often described as musical and harmonious, French is considered to be the most romantic language in the world. In fact, Google reports a high proportion of French translations are to do with love – 'je t'aime' is the most frequently requested translation, closely followed by 'mon amour', meaning 'my love'.

FRENCH

Text doesn't always have to be straight, you can draw it to fit along curves or uneven lines too.

Draw out guidelines before your start for where you want the text to sit. This will give you a smooth line (if that's what you're after!) or at least give some structure to your design so that you're not left with the pressure of freestyling.

Make different pairs of lines that taper, curve or zigzag and draw your lettering to sit between them.

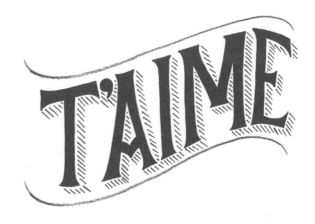

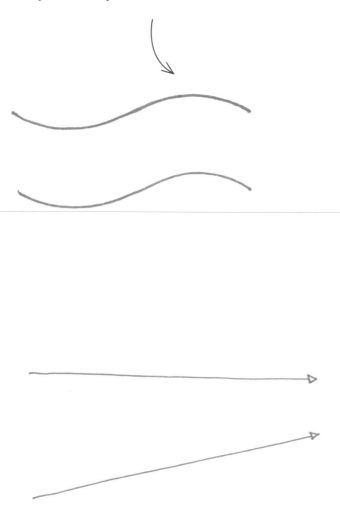

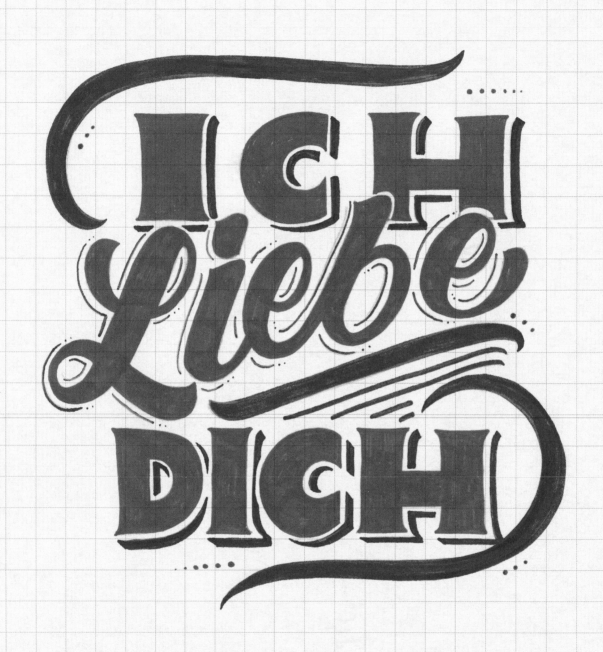

GERMAN

ICH LIEBE DICH

As well as 'Ich liebe Dich', you could also try some German terms of endearment like 'Schatz' (sweetheart; literally treasure), 'Liebling' (darling) or even 'Schnucki' for which there is no definitive literal translation, but it sure sounds cute.

To emphasize a letter, you can make it look three-
dimensional so that it appears raised from the page.

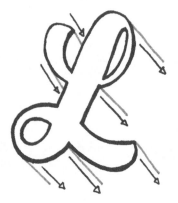 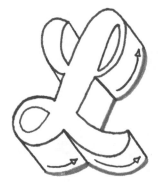

Start by drawing lines from
the edge of the letter all in the
same direction. The length of
the lines will be how deep the
raised effect is.

Then complete the three-
dimensional effect by joining
up the lines, following the
curves and lines of the
original flat letter.

Colour in the sides of the
letter, or the letter itself,
so that it stands out better.

Try the technique for yourself with your own letters and shapes.

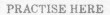
PRACTISE HERE

GREEK

SE AGAPÓ

Greek is one of the world's oldest languages. Written records show that it
spans 34 centuries, and many modern European languages have words that come from Greek.

Adding a gradient can create the illusion of light or shines on letters and be used to emphasize specific letters or words. As well as the more conventional ways of adding gradients by varying the pressure using a pencil, or by blending different shades of colours together, you can also use patterns as gradients.

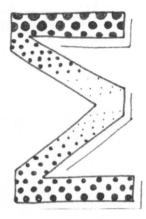

Drawing large dots getting smaller can be used to achieve a nice half-tone printed appearance, and also tricks the eye into thinking there is light shining where the dots are smaller, giving a highlighting effect. Similarly you can use stripes that get thinner, or further apart, to give the effect of a gradient. You can also build up a higher density of strokes where you want a letter to look dark, and then thin out the density of strokes where you want it to look lighter.

Using these pattern techniques means that you can still achieve a gradient effect with pens, even though they can't achieve the smoother blending gradients that pencils can.

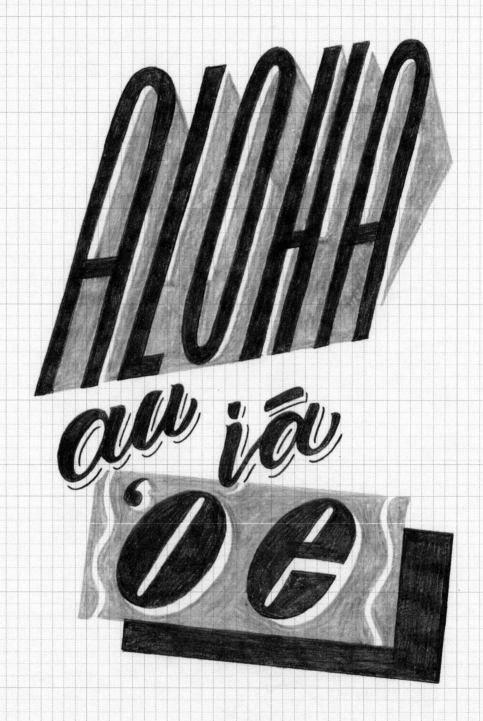

HAWAIIAN

ALOHA AU IĀ ʻOE

The Hawaiian alphabet is made up of only 12 letters – 5 vowels and 7 consonants, making it one of the shortest in the world. As well as meaning 'love', the word 'aloha' on its own can be used to say 'hello' and 'goodbye'.

HAWAIIAN

Black and white can be very dramatic as a colour
scheme, and is particularly effective for when
your design involves highlights and shadows,
or block shading.

Experiment with alternating between white on
black and black on white lettering, and adding
shadows, shading and patterns to different
letters and shapes using only black and white.

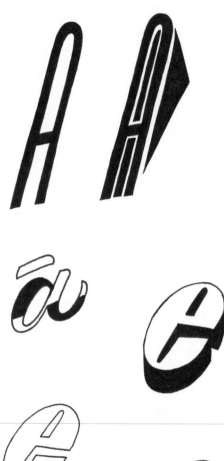

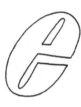

HEBREW

The way to say 'I love you' in Hebrew is determined by gender:
If a man is speaking, it is written the same but pronounced differently depending on who he is addressing:

אני אוהב אותך
man to a woman: (ani ohev otakh)

אני אוהב אותך
man to a man: (ani ohev otkha)

If a woman is speaking, it is written the same but pronounced differently depending on who she is addressing:

אני אוהבת אותך
woman to a man: (ani ohevet otkha) (as above illustration)

אני אוהבת אותך
woman to a woman: (ani ohevet otakh)

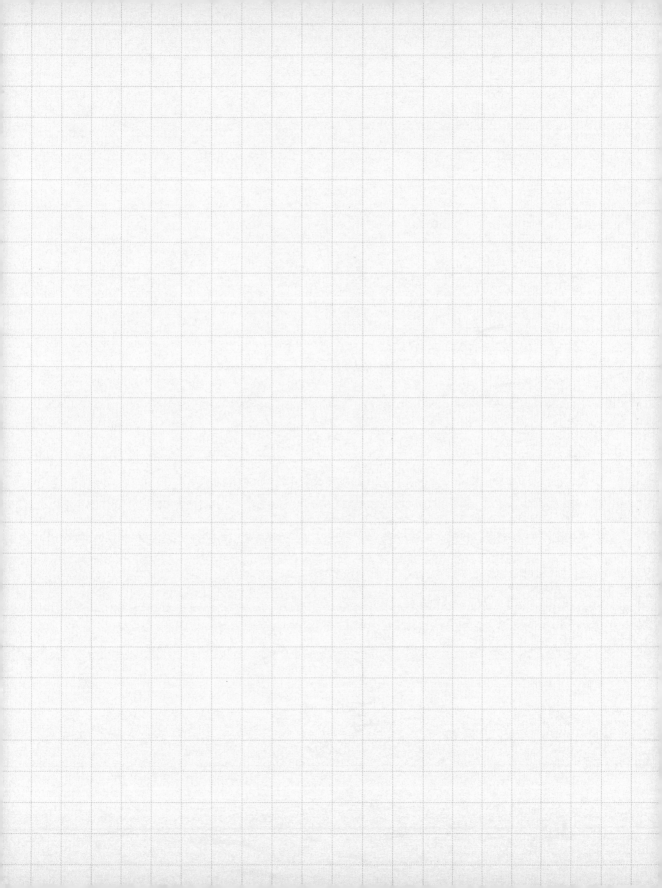

HEBREW

You can design whole alphabets and character sets based on shapes or items that you like and are inspired by. My design for the Hebrew illustration, for example, was inspired by the fluidity and shape of ribbons.

Using the outlines given below, draw shapes and patterns along or inside them to create your own lettering styles. You could try drawing leaves, flowers or rope, and then applying the styling to your own letters.

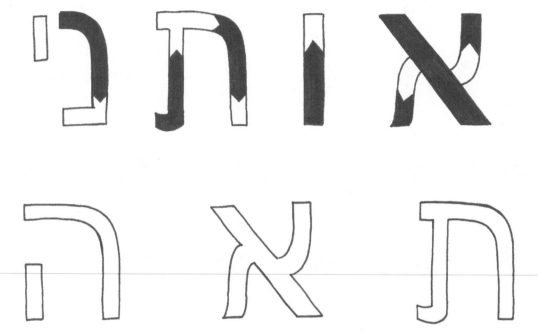

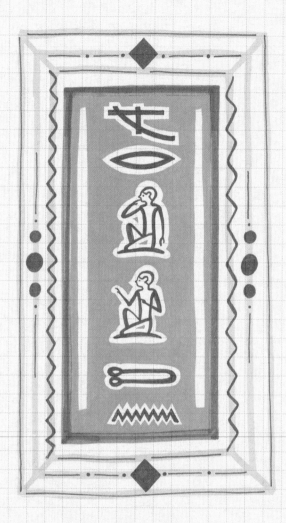

HIEROGLYPHICS

Take a leaf out of the ancient Egyptians' papyrus and convey your feelings in hieroglyphics (or 'sacred engraved letters'). There are four ways of writing 'I love you' determined by gender:

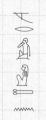

man to a woman
(mer-ee tchen)
(as above illustration)

woman to a man
(mer-ee tchoo)

man to a man
(mer-ee tchoo)

woman to a woman
(mer-ee tchen)

HIEROGLYPHICS

Borders can come in any shape or size, and you can experiment with them to add detail and bring your lettering together as a single illustration, or to surround individual letters or characters.

Add some shapes as borders to these hieroglyphs and your own letters or words. They don't have to be a classic rectangle or square shape, why not experiment with 3D shapes, abstract shapes, circles or objects?

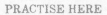

HINDI

The Hindi language uses Devanagari script that is written from left to right, and there are two ways of writing or saying 'I love you' depending on the gender of the speaker:

मैं तुमसे प्यार करता हूँ

(said by a man to a man or woman, as in above illustration) main tum se pyār kartā hūn

मैं तुमसे प्यार करती हूँ

(said by a woman to a man or woman) main tum se pyār karti hūn

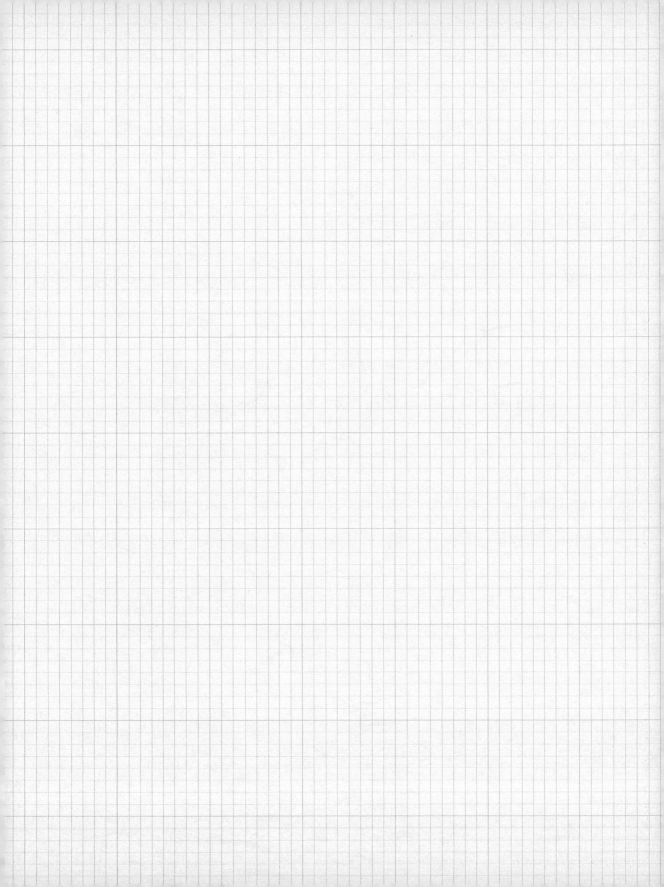

Contrasting colours can make for a bold statement in your lettering. Colours that contrast with each other sit opposite each other on the colour wheel, so purple and yellow, blue and orange, green and red.

Using clashing, contrasting colours isn't necessarily a bad thing. It can be very eye-catching compared to using complementary colours, especially if you choose bright ones. Choose some pairs of contrasting colours to try out and see which colour schemes you like best.

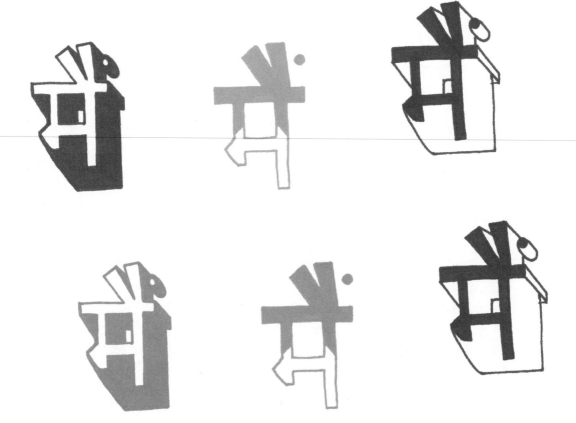

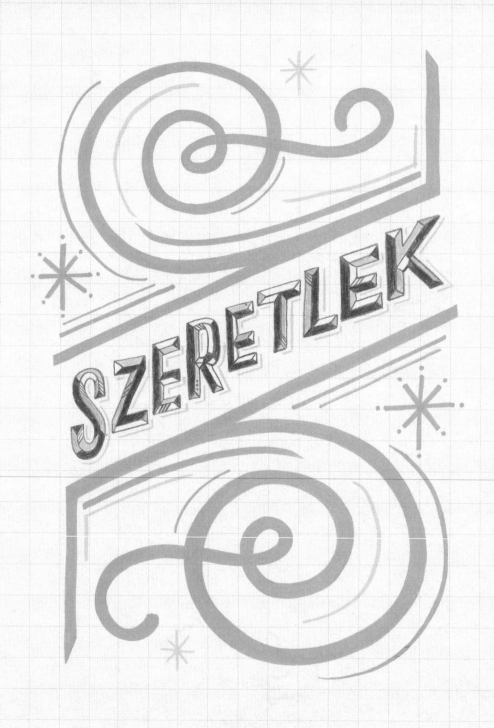

HUNGARIAN

SZERETLEK

Hungarian, or Magyar, as the language is known to native speakers, is considered one of the hardest languages to learn. Pronounce 'seh-ret-lek' correctly and you're sure to doubly impress your Hungarian crush.

You can create the look of bevelled lettering
using some clever linework and shading, to make
it appear as if your lettering is three-dimensional
and has been cut away.

Start by drawing a line in the middle of each
part of the letter or character. Then add a triangle
at the end of each stroke. Colour in the segments
of your lettering in any way you like up to the
middle lines you've drawn – this adds to the
illusion of a raised surface.

This geometric style works well with colour and
patterns added to the small segments of the letters,
to give the effect that the letters are made of
panes of mirrors or glass reflecting in different
directions. Try the technique out for yourself.

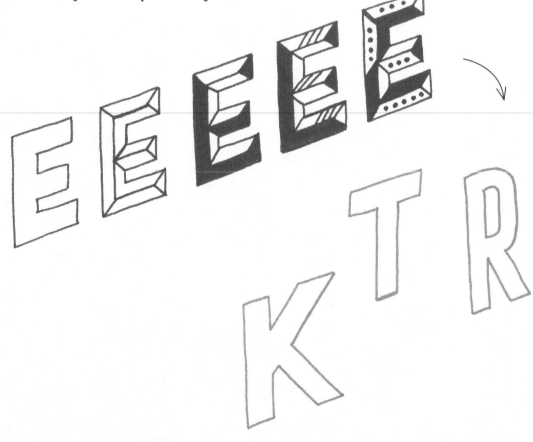

PRACTISE HERE

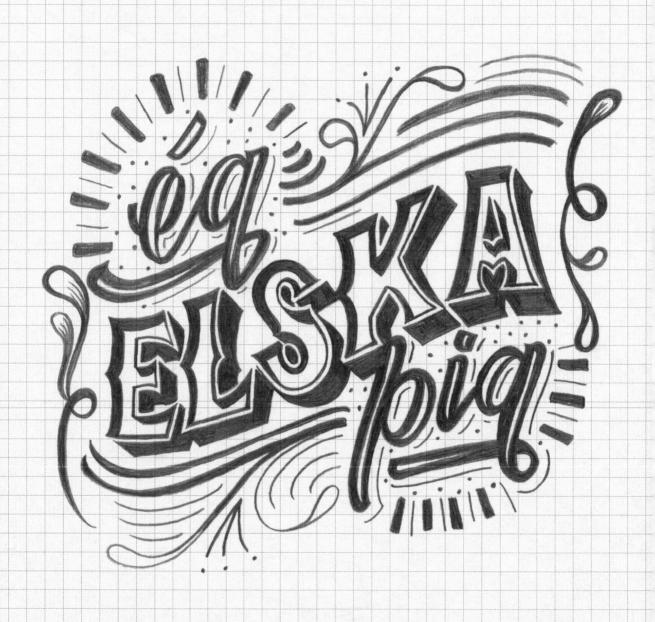

ICELANDIC

ÉG ELSKA ÞIG

Learning Icelandic will go down very well with locals! The native language is important to Icelanders, and every year on November 16 they celebrate 'the day of the Icelandic tongue'.

You can achieve some really fun and interesting effects by choosing shapes to start and then drawing lettering to fit inside them, whether that's individual letters, whole words or even phrases.

Experiment with drawing letters, characters, words and phrases to fit different shapes. The shapes might relate to what the word or phrase is, such as fitting 'I love you' into a heart or 'star' into a star, or they can just act as design features. You could even challenge yourself to create an entire alphabet or character set where they all fit into triangles or circles or any other shape you can think of!

IRISH

TÁIM I NGRÁ LEAT

Irish (or Gaeilge, as it is called in Irish) is the official language of the Republic of Ireland.
Make a grand gesture to an Irish beau with a traditional Celtic Claddagh ring, a symbol of love, friendship and loyalty.

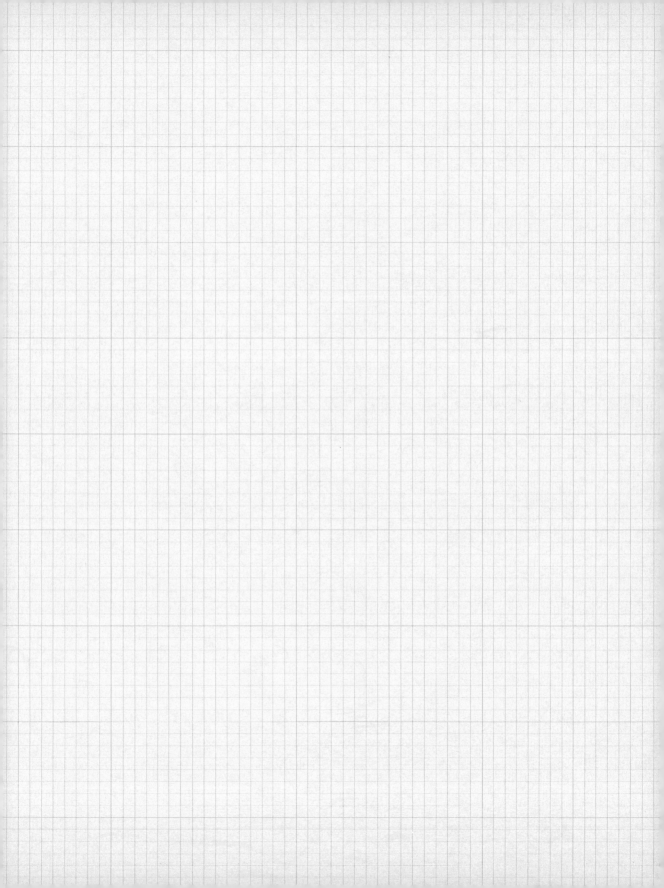

Once you have drawn out your lettering, you can then decide what colour scheme to use to decorate it. You might have an idea in mind that ties in to what the text says, or just want to use a classic scheme that you know will look good.

Why not try using a colour scheme based on your favourite colours or the colours of a particular team or place? Or go for a red and white striped candy-cane effect, or yellow stars on a blue background to look like the night sky? Use your imagination to come up with some themed colour schemes and try them out here. That way, you can refer back to them when you want ideas for colour schemes in future work too and know what they look like already.

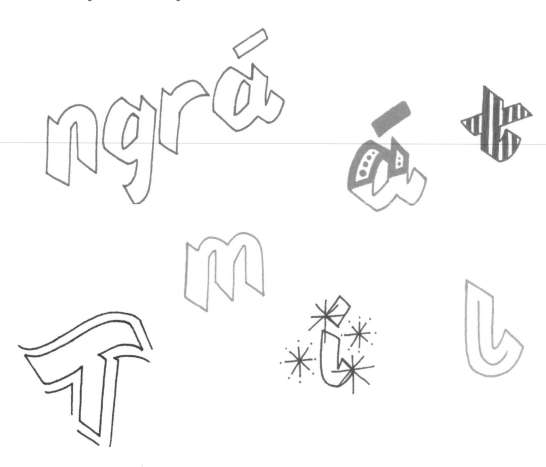

ITALIAN

TI AMO

St Valentine who gives his name to the celebration every year on February 14th was born in Terni,
a small town in Italy, and Shakespeare's *Romeo and Juliet* takes place in the Italian city of Verona. Indeed it would
be hard to find a country with more romantic credentials than Italy, and the Italian language is beautiful too!

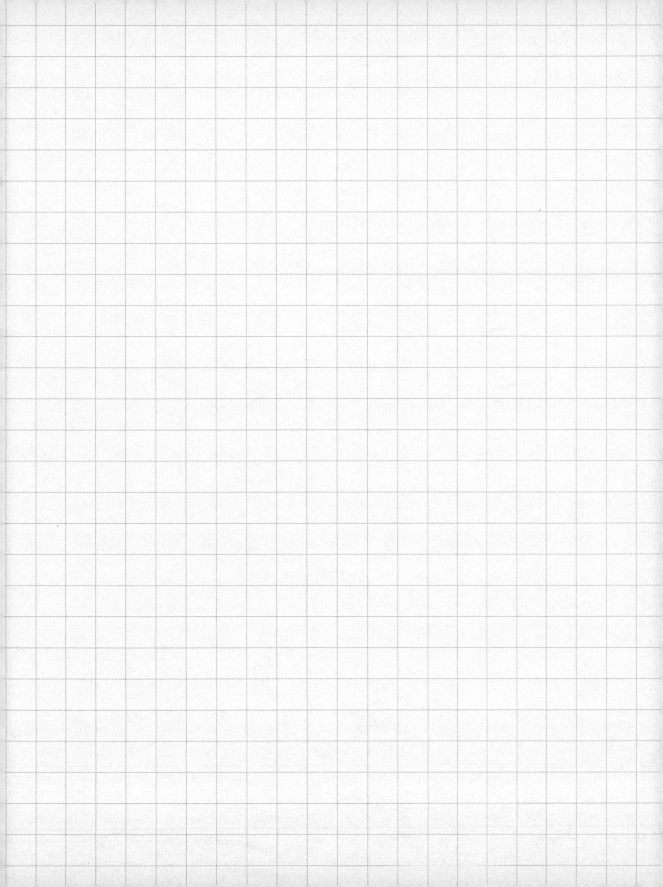

ITALIAN

You can give your lettering the appearance of
speed as though it is flying across the paper
by adding a few speed lines.

Once you have designed the style of lettering that
you would like to use, whether 2D or 3D, simply add
a few small lines flying out from the lettering to
one side. This technique can work with any letter or
character, and if you pair the speed lines with an
italic style of lettering that leans in the opposite
direction to the way the lines are going, this will
make it look like the lettering is also physically
distorted because of how fast it is moving!

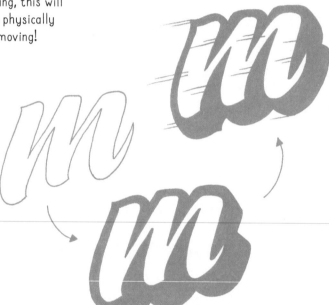

JAPANESE
DAISUKI

Japanese is made up of three writing systems that all have different uses, making it one of the most complicated written languages in the world. On Valentine's Day in Japan, girls have to give boys presents, but boys are expected to give presents to girls on White Day (March 14) and spend twice as much! Before making any love declarations, it's also customary to 'confess' your intention to begin a relationship, known as 'kokuhaku'.

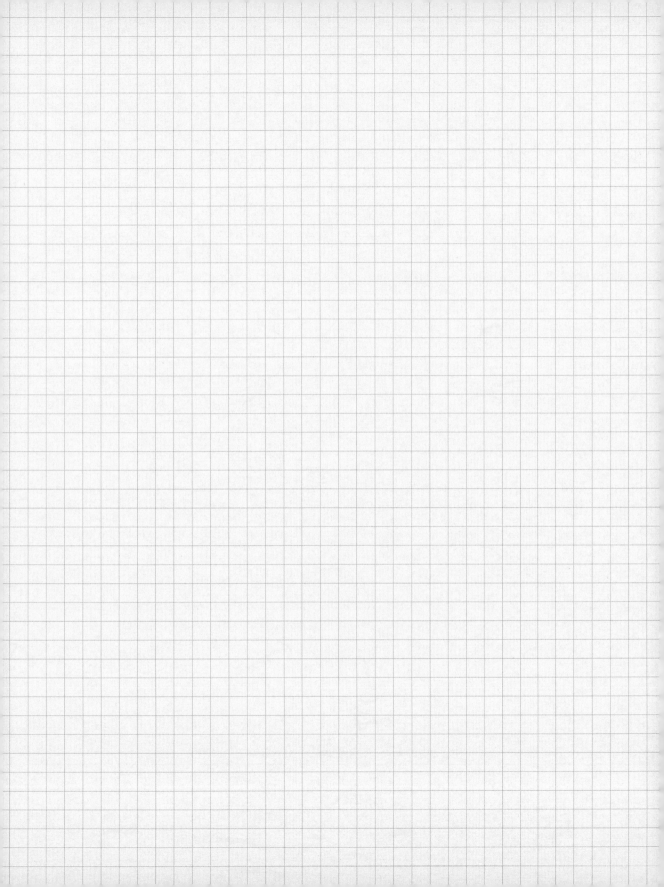

This technique is inspired by the many street
signs made up of neon strip lighting, in their bright
fluorescent colours that look especially good at night.
To create your own neon strip-lighting effect for
your lettering, start by drawing out your lettering
as normal, but when you come to colouring it in, leave
a thin line of blank space all the way through the
letter or character. This line can then either be
coloured in a lighter colour or left blank or white.

Practise the neon strip technique on the shapes
here, then try it with your own shapes, letters and
characters. You can also add pattern details, shadows,
3D effects, or why not try linking all your lettering
together so that it looks like it's a sign made from
one continuous neon strip?

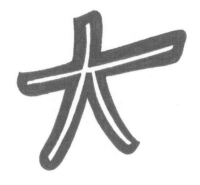

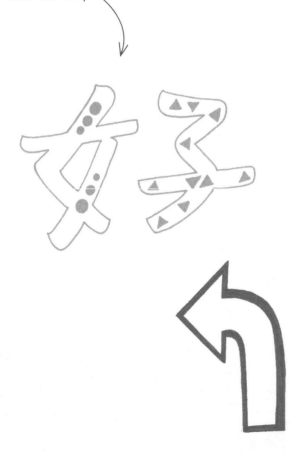

KOREAN

SARANGHAE

This is a handy phrase in Korea, as it's common for couples to mark anniversaries every 100 days and observe special celebrations on the 14th of every month; these include Diary Day (where blank diaries are exchanged), Green Day (to be held in nature) and Hug Day!

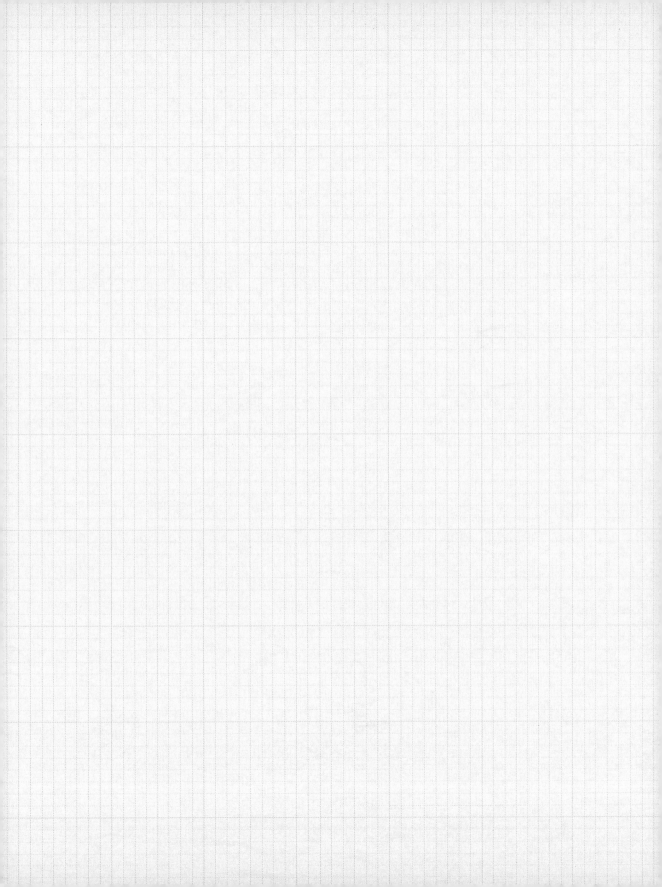

You aren't restricted to using patterns to
decorate just your letters, so why not mix it up
and use patterns for your drop shadows and 3D
shapes too? Make sure to keep the main focus on
the letter in the foreground, adding subtle detail
to create depth or a shadow effect, otherwise it
will look too messy and hard to read.

Try using dots, bubbles, thin stripes, small stars,
anything you like, to create your depth or drop
shadow. With the contrast between the bold
letter in the foreground and the softer 3D
or shadow effect, it can add another level
of detail and sophistication to your design.

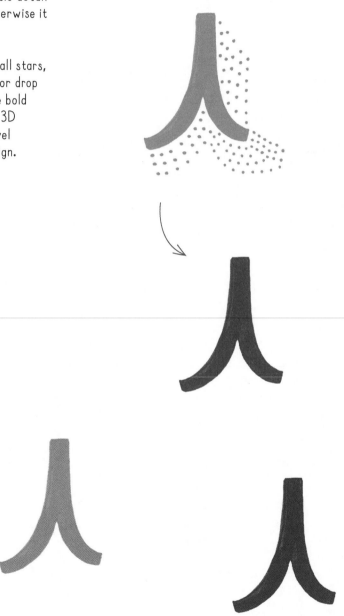

LATIN

TE AMO

Although Latin is no longer spoken, it is still studied today.
It developed into the Romance languages, such as French, Spanish and Italian, which is why
'I love you' in Italian sounds similar in Latin; and why it is also the same in Spanish.

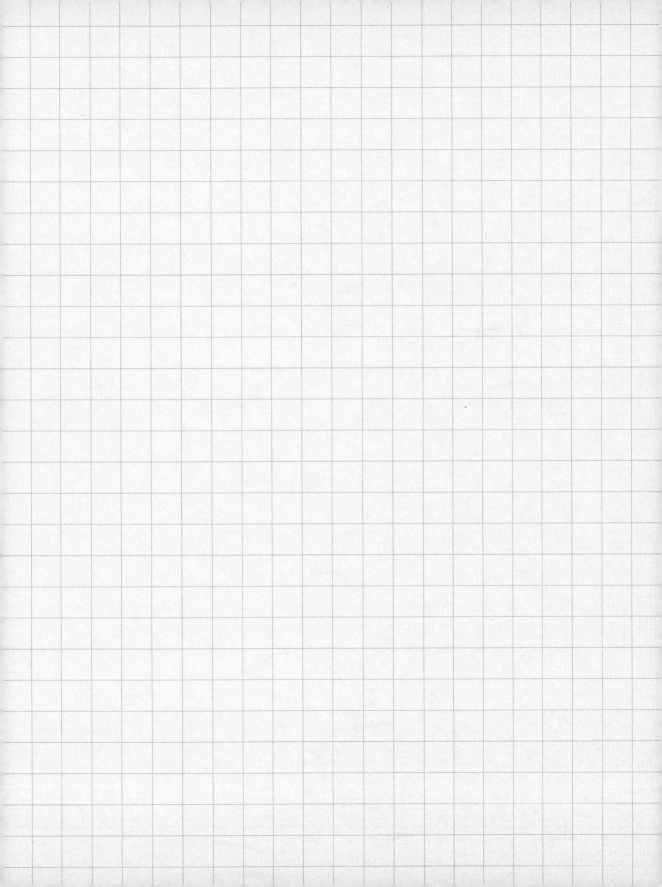

You can make it appear as if your lettering is disappearing into the distance to give it the illusion of depth by using perspective.

Vanishing point

Start by picking the point where you want the letter to disappear to (this is known as the vanishing point, and can be anywhere you like, but if it's further away from the letter it tends to have a more dramatic effect.) Then lightly draw a line in pencil from each corner of the letter to the vanishing point. Use these pencil construction lines to finalize the perspective effect, and rub them out afterwards to leave a clean design.

Try it yourself with these letters, and your own letters, characters and shapes.

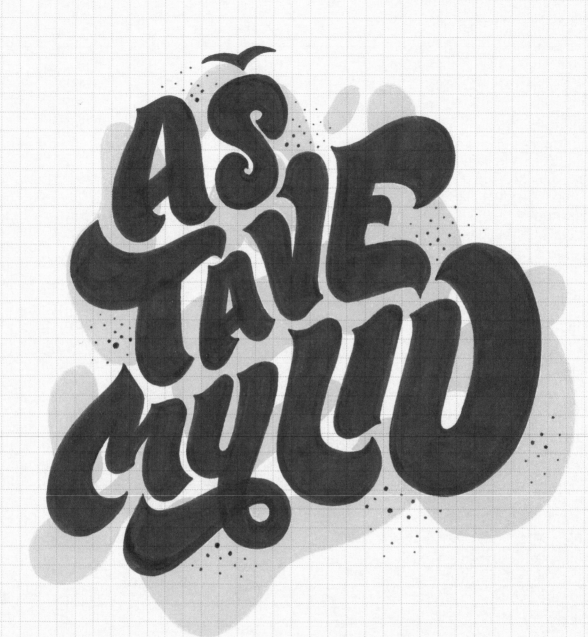

LITHUANIAN

AŠ TAVE MYLIU

Lithuanian is a Baltic language and among the world's oldest surviving languages
with links to Ancient Greek, Latin and Sanskrit.

For the Lithuanian lettering illustration,
I used a warping technique to create a
magical 60s-inspired style.

You can use the same technique to warp or
distort lettering however you want to. First
take a regular letter or character drawn out
simply. Then think about how you can take
each line and bend it, or shift it in a different
direction. If you do this for every line, it will
leave you with a completely different style
of lettering that will hopefully still be legible!
Keep playing with the distortion effect until
you find a shape you're happy with.

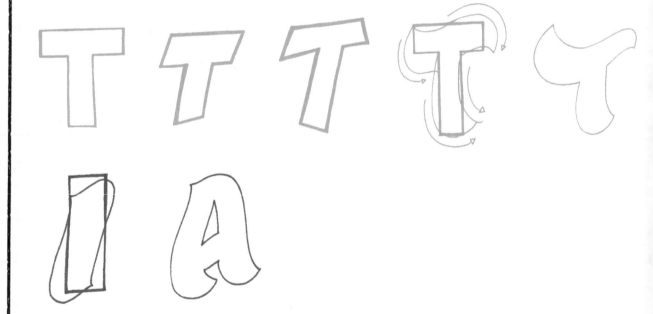

MAORI

KA NUI TŌKU AROHA MŌU

Maori is the official language of the indigenous population of New Zealand and is closely related to all the Polynesian languages across the Pacific Ocean. Try this proverb: 'Ko Hinemoa, ko ahau', meaning 'I am just like Hinemoa; I'd risk all for love'. It is based on a local legend about two Shakespearean-esque star-crossed lovers, Hinemoa and Tūtānekai.

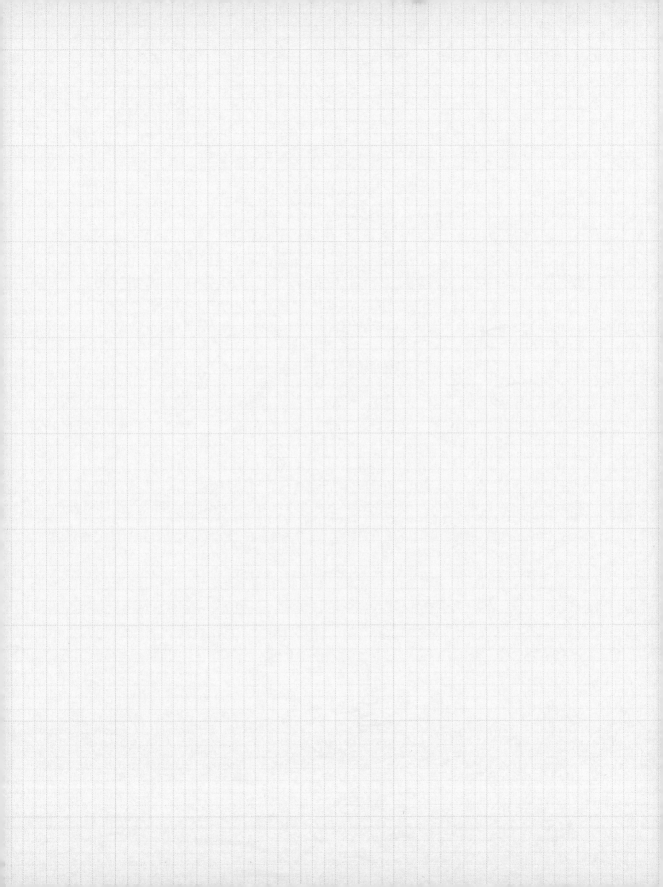

MAORI

Although you can create lettering digitally on a computer, and some script fonts are also very good at mimicking handwriting, what marks hand lettering out is that it is unique - only you can letter that way, and each letter or character you write will be different as you are not a machine! Even though you might have a specific style or handwriting, when you write two of the same letter, they probably won't be exactly identical.

One of the joys of hand lettering is this individuality you can bring to make a really expressive piece of lettering, which is almost impossible to replicate digitally. Why not experiment with showing off the media you are using, so that you can see smudge effects or the felt tip pen or pencil strokes in your shading? Or play up the irregularities in your lettering so that it is deliberately imperfect, with some letters bigger than others, with flicks and swooshes on some letters but not others? These are the kinds of elements that give hand lettering its charm.

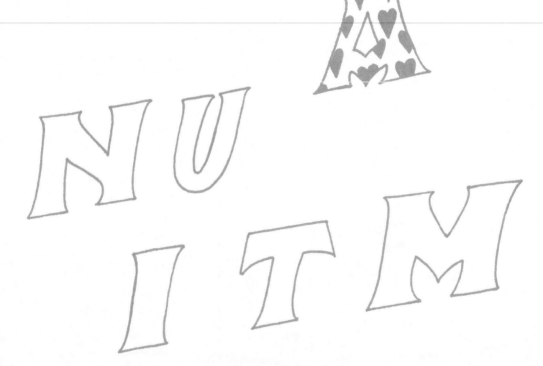

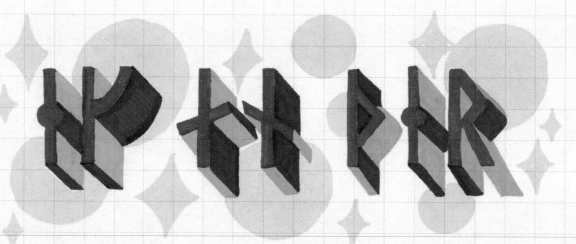

NORSE RUNES

EK ANN ÞER

This is how to say 'I love you' in Old West Norse, although another less
common way is 'eh elska þik':

ᚼᚠ ᛁᛚᛋᚴᛅ ᚦᛁᚠ

Whereas the word 'alphabet' comes from the starting letters 'alpha' and 'beta', rune systems
are called 'futharks' because they start with 'f–u–þ–a–r–k'. The futhark used here is a Viking-age
one made up of only 16 characters.

To create a background that looks like it sparkles, all you have to do is use different-sized stars and circles. By making them different sizes, it gives the appearance of movement.

You can use any shape to make a patterned background, and by making the shapes different sizes, it adds movement to whatever the pattern might be, for example, snowflakes, raindrops, hearts. It is a good idea to use a lighter colour for your background though, as darker colours can distract from the lettering, especially if there isn't a gap between your lettering and the background.

NORWEGIAN

JEG ELSKER DEG

Norwegian is a North Germanic language like Swedish, Danish and Icelandic.
Sometimes called the Nordic languages, these languages all developed from the language
of the Vikings, Old Norse, and you'll notice the translations for 'I love you' are similar.

Adding a simple extra line of colour as a shadow
can give lettering a subtle raised effect as if
it is embossed.

Using the same technique as you would for shadows,
thinking about where the light is coming from, draw
a thin extra line wherever there would be a shadow
where the light wouldn't fall.

Practise here on these letters and on your own
letters. This technique tends to work better with
bolder designs otherwise it can start to look quite
fussy and complicated because of the extra lines.

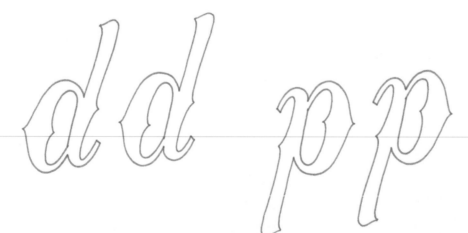

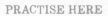

PERSIAN

DŪSTAT DĀRAM

Persian is the official language of Iran (where it's called Farsi), Afghanistan (called Dari) and Tajikistan (Tajiki). It's considered one of the most beautiful languages in the world for its soft, poetic and melodic qualities, and it looks pretty good when written down too!

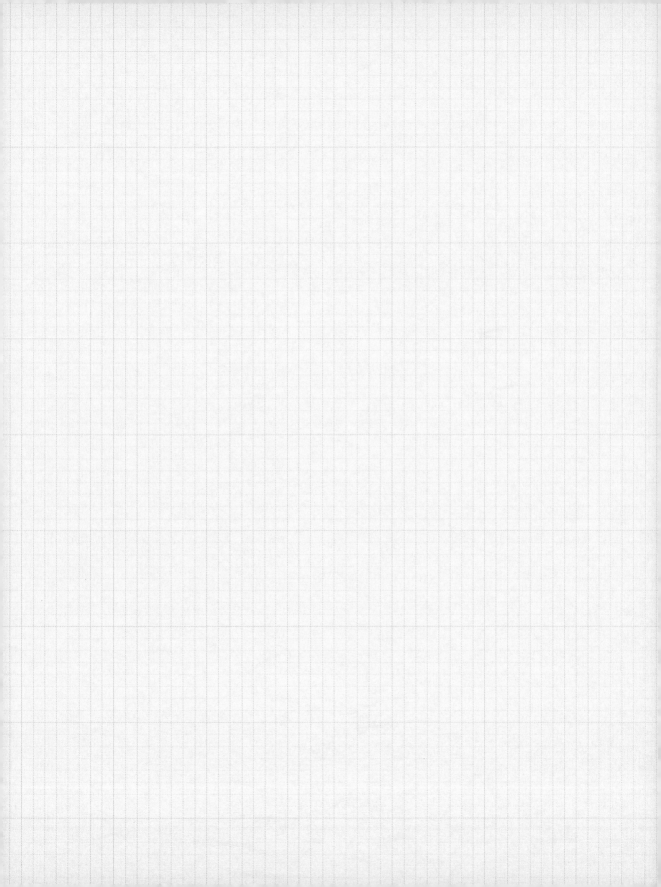

You can use effects to make it look like your
lettering is made from different materials. Look up
image references to help you come up with patterns
and designs based on how materials look in real life.
It can be fun to experiment with designs that include
whorls to imitate the look of wood; or the shines and
lines that you can see in metal for example.

You could even add extra details to the lettering to
emphasize the look of the material, such as adding
twigs and leaves to wooden lettering, or block 3D
and shading effects to metal lettering.

POLISH

KOCHAM CIĘ

In Poland you will find a lot of terms of endearment based on animals, such as 'Żabko' (froggy), 'Tygrysku' (baby tiger), 'Myszko' (mouse) or 'Króliczku' (bunny). 'Kwiatuszku' (little flower) and 'Truskaweczko' (strawberry) are other popular examples of endearments! If you're buying flowers too, make sure there is an odd number of blooms: it's considered bad luck in Poland to give an even bouquet.

POLISH

A fun way to personalize your lettering is by incorporating shapes into your letters or characters. This is easiest where the letterforms have dots (such as i, j, question marks, exclamation marks or full stops) or blank spaces (in an O, P, a or d for example).

Try replacing dots and spaces with shapes. You can use any objects or shapes you like for this, such as hearts, diamonds, stars or apples. But also look at other letterforms and characters and imagine how you can replace them, you could turn an M into mountains, or I into an arrow for example. This technique works especially well when creating logos and with bolder designs. Experiment with adding shapes to dot the letter i's here as a starting point.

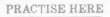

PORTUGUESE

EU TE AMO

Portuguese is the official language of nine countries, including Portugal, Brazil and Mozambique.
If you're feeling particularly adventurous you could even try embroidering your declaration of love
on to a handkerchief in the way of the old Portuguese tradition to give to your loved one!

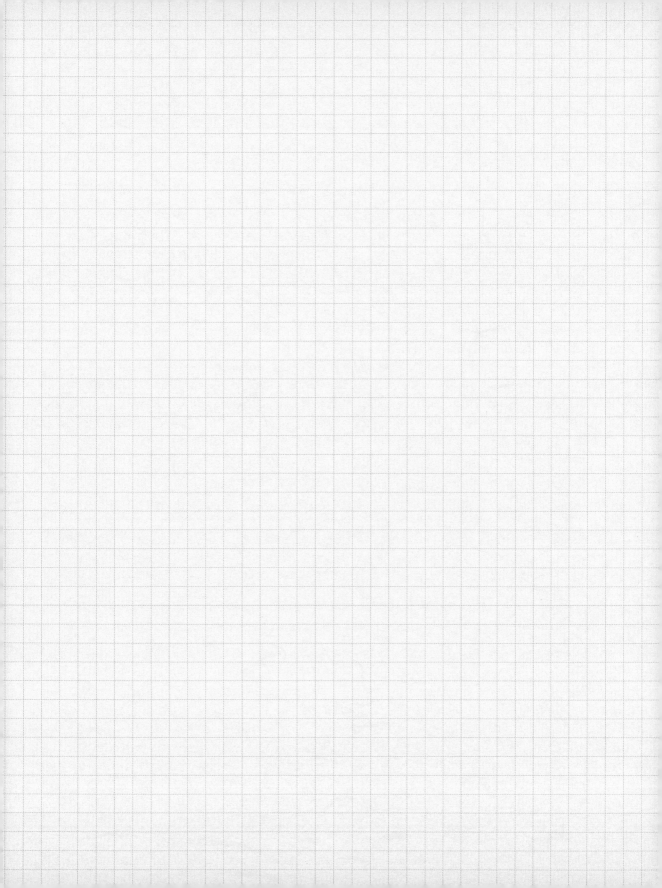

Drawing 3D lettering at an angle allows you to create the illusion that it is floating in space. This technique is often referred to as isometric drawing, and you can also get isometric graph paper to help you with your designs. The idea is that all lines that are normally vertical remain vertical, and all lines that are normally horizontal are instead all parallel at the same slanted angle.

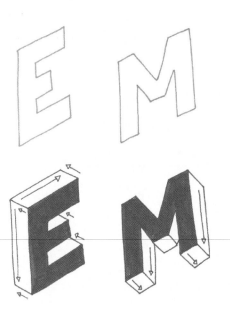

If you look at the E and M here you will notice that they are both drawn at the same angle, it is only when you add the 3D effect, extruding the letters in different directions, that they appear to be on different planes entirely.

Much like for normal 3D lettering, once you decide on the direction you would like your lettering to be extruded, you can then construct the shape by drawing lines in that direction. So if you want the isometric letter to be extruded upwards, you would draw lines from each corner of the letter at the same upward angle. And if you want the letter to be extruded downwards, you would draw lines from each corner of the letter at the same downward angle. Then you join up all the extended parallel lines to create your block letters.

Practise making these letters 3D, and then try the 3D isometric technique for yourself on your own lettering.

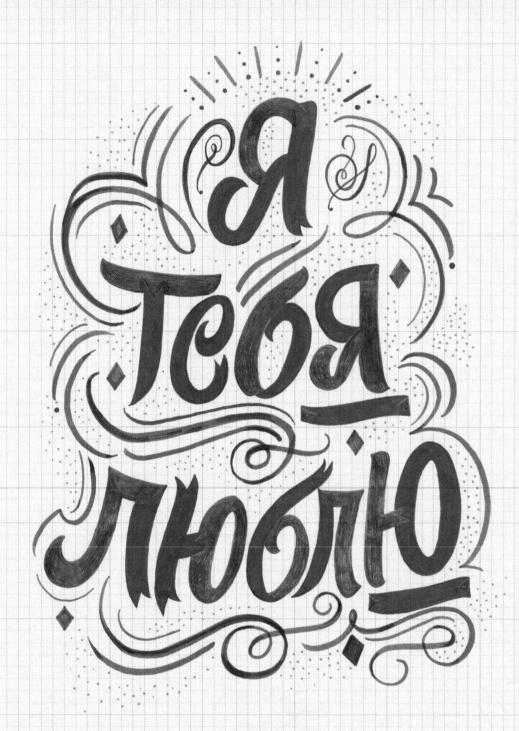

RUSSIAN

YA TEBYA LYUBLYU

The Russian alphabet is made up of 33 letters based on the Cyrillic script letters invented by two monks called Cyril and Methodius. Russian is often referred to as being the 'international language of space' and all astronauts who travel to the International Space Station (ISS) need to know how to speak Russian fluently!

RUSSIAN

In my Russian example illustration, I have used a dot technique to build up a texture pattern around the lettering. It's an understated way of adding colour and detail to a design, and you can use any small marks to achieve the same effect.

Why not try adding small dots, hatching marks or crosses to create a fine textured pattern around some of these letters? The key is to make the marks really small so that they don't overwhelm the design.

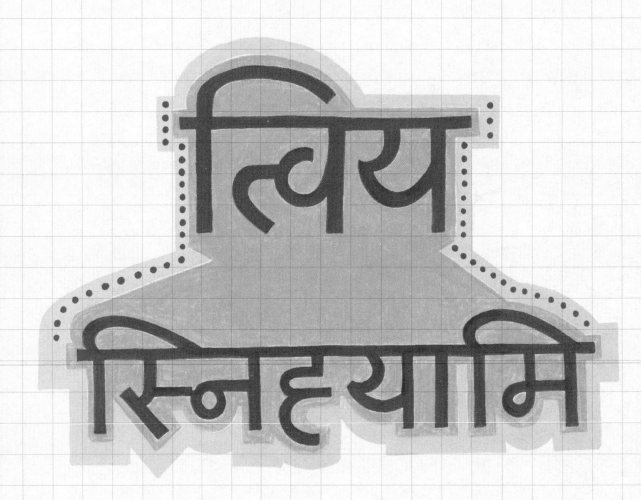

SANSKRIT

TVAYI SNEHAYĀMI

Sanskrit is considered the most unambiguous of all languages.
It is rich with synonyms — there are 100 different ways to say 'elephant'.
You can chose from 96 synonyms for the word 'love' to perfectly convey your feelings.

SANSKRIT

You might want to add a border that surrounds
an entire word or phrase to tie it all together.

For the Sanskrit example illustration, I followed
the shape of the lettering to make the border, to
give an interesting irregular shape. You can do the
same thing for any word or phrase, and then decide
how to decorate your border with further detail
such as a series of dots, lines, diamonds or zigzags,
in any colours you like.

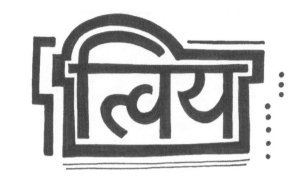

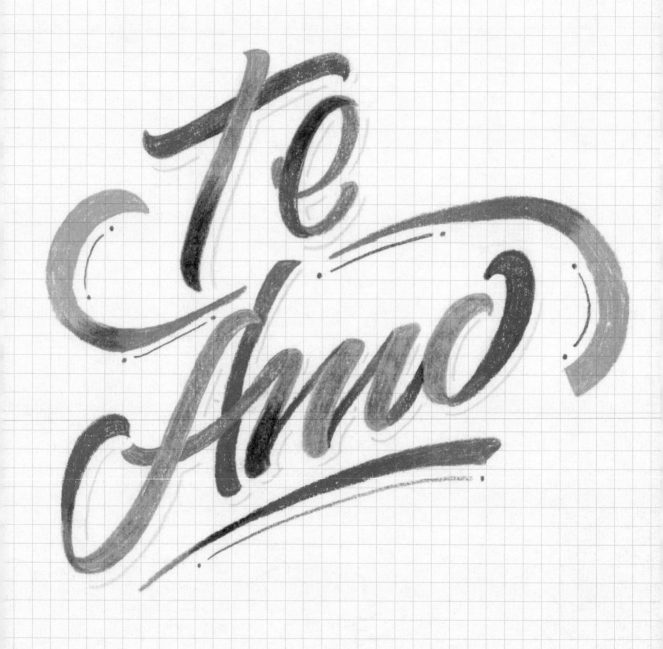

SPANISH

TE AMO

Spanish is the second-most-spoken language in the world after Mandarin Chinese,
and is the official language of 21 countries including Spain and many Latin American countries.
Try 'te quiero' as another way of saying 'I love you' for a more casual expression of non-romantic affection.

SPANISH

In the Spanish example illustration, I have
made it look like the lettering is made up of
multicoloured strokes.

To try the technique yourself, first build up your
letters or characters one by one, by drawing each
stroke individually as separate parts. Then colour
in each stroke segment a different colour, or to
get even more of a rainbow effect, blend different
colours together in a gradient for each stroke.

You could also experiment with adding patterns
to some of the stroke pieces to add further
detail and emphasis.

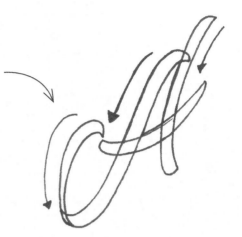

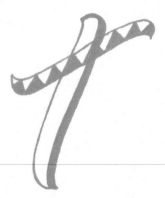

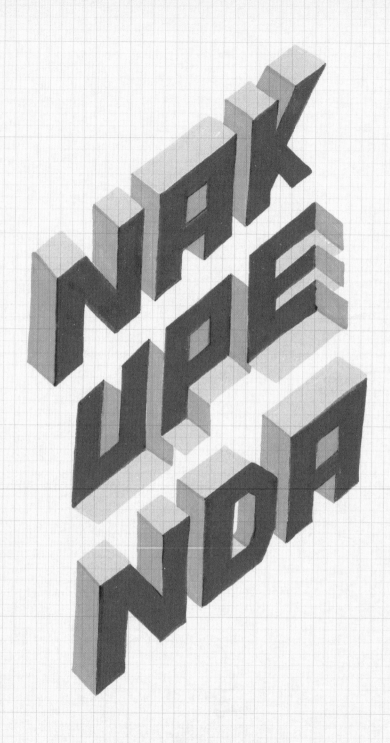

SWAHILI

NAKUPENDA

Swahili is one of the most widely spoken languages in Africa, and is the official language of the Democratic Republic of the Congo, Kenya, Rwanda, Tanzania and Uganda. Also known as 'Kiswahili', Swahili derives its name from the Arabic word for coast, 'sāhil'.

You might also want to try incorporating a banner or badge into your design to surround your lettering. Banners and badges are really types of frames and borders, except that banners traditionally look like oversized ribbons or scrolls, and badges tend to take the form of shields, starbursts or rosettes. They're great for decorating your lettering and can be as fun or ornate as you like.

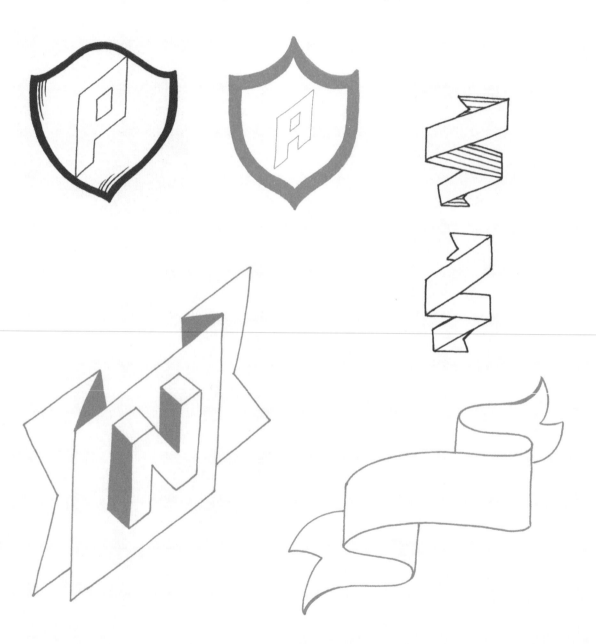

PRACTISE HERE

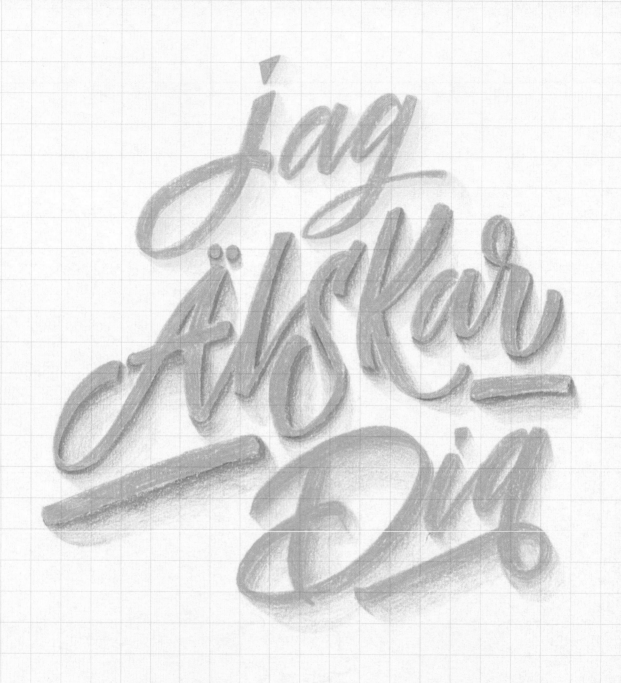

SWEDISH

JAG ÄLSKAR DIG

Swedish is one of the North Germanic languages, and can also be understood by speakers of
Norwegian and Danish. A big part of Swedish culture is a 'fika' which is a Swedish cake-and-coffee break,
and workplaces even incorporate a fika break in the mornings and afternoons! It's a good way of getting
to know somebody, so you could always ask them to go for a 'fika' with you like you would for a date.

When working in coloured pencil, you can use blended gradients with your 3D and drop shadow effects to create a floating, ethereal feel to your lettering.

The idea is to draw out your 3D effect or drop shadow as you normally would, as lightly as possible in graphite pencil. Then when it comes to colouring in the design in coloured pencil, the closer you are to the lettering itself, the darker you shade the shadow or 3D effect. The further away you are, the lighter you shade to give the gradient effect.

It's important to draw your graphite pencil construction lines as lightly as possible so that when you come to erase them you don't erase the coloured pencil too. Alternatively you could copy out or trace the design onto a new sheet of paper once you have drawn out your construction lines, working from them as a plan, so that you don't have any pencil lines to erase at all! Try the technique out on these letters here.

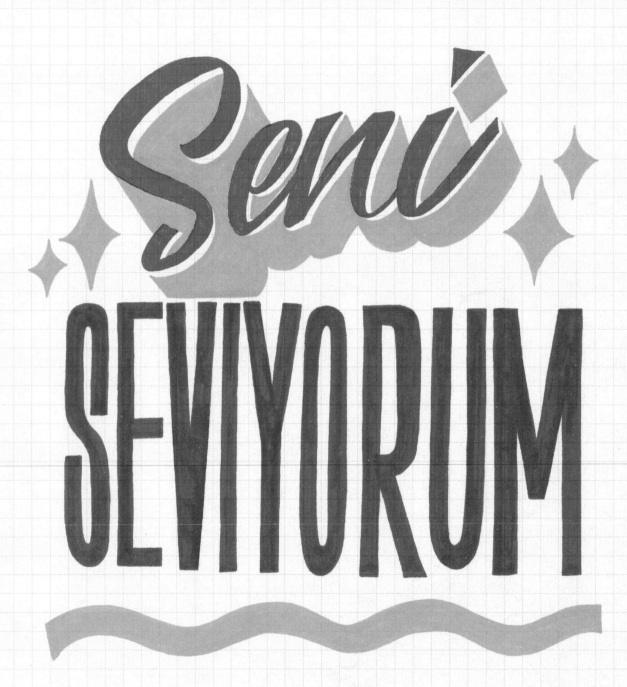

TURKISH

SENI SEVIYORUM

Turkish used to be written in a form of Arabic but is now written in a variation of the Latin alphabet made up of 29 letters.
If you were feeling generous, you could always make a cup of coffee for your loved one to go with your love note – Coffee is so important
to Turkish culture that it used to be said that if you were good at brewing coffee, you would make a good wife!

You can stretch text horizontally or vertically to create impact. It's important not to stretch letters too much though, as they become hard to read.

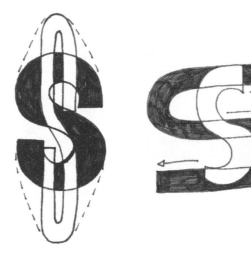

You can also play with perspective by stretching lettering to make it wider at the bottom than at the top and vice versa, to create the illuson that you are looking up or down at it respectively.

Try stretching letters or characters in different directions to see what effects you can achieve.

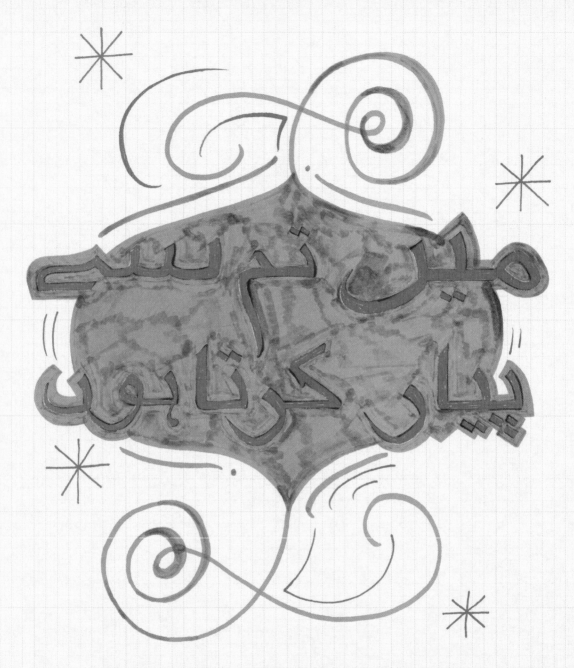

URDU

Hindi and Urdu are almost exactly the same when spoken, but their scripts are different and Urdu is written from right to left. The Urdu alphabet has 58 letters, derived from Arabic. There are 2 ways of writing or saying 'I love you' depending on the gender of the speaker:

میں تم سے پیار کرتا ہوں

(said by a man to a man or woman) main tum se pyār kartā hūn (as illustrated above)

میں تم سے پیار کرتی ہوں

(said by a woman to a man or woman) main tum se pyār karti hūn

With this technique, you can make it look like your lettering is being reflected in a mirror or water.

First draw out your lettering while remembering to leave enough space for you to draw the reflection afterwards. Then in pencil, copy your drawing as a mirror image. It might help to turn the paper around before you draw the reflection, or to plot out the reflection using graph paper first if you want to be more accurate. But reflections are often a bit distorted so it doesn't have to be a perfect copy, and could even add to the effect.

How you colour in or add detail to the reflection afterwards is up to you, you might just want to make it a different colour, or a lighter or darker shade to the one you use for the original lettering. Or use a different medium. You could even make it look like the reflection is blurry or smudged as if it is reflected in water. Practise on the lettering here and on your own examples.

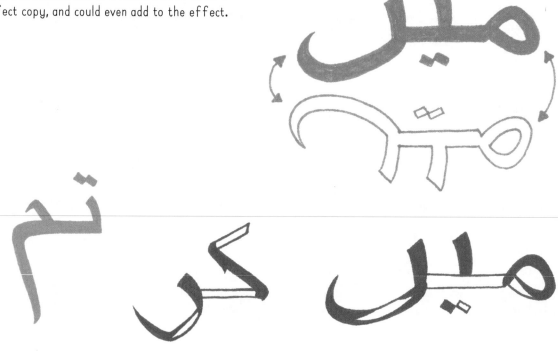

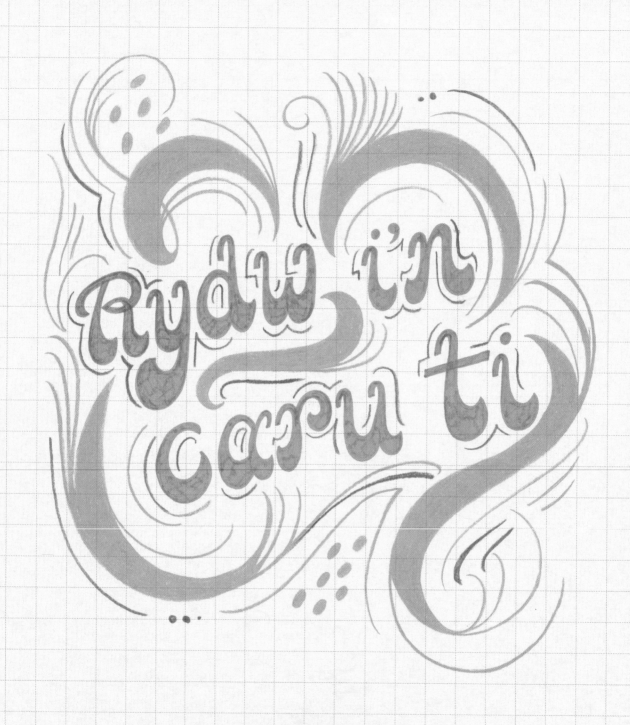

WELSH

RYDW I'N CARU TI

Welsh, or Cymraeg, is an ancient Celtic language dating back around 4,000 years.
If you're looking for a romantic gift idea, you could try a traditional lovespoon — in Wales
these are hand-carved, decorated wooden spoons that symbolize love.

Rules were made to be broken. So why not
experiment with combining different styles of
lettering together in one word or phrase? It can be
interesting to contrast different styles next to
each other - you might want to mix up sans serif,
serif and script letters; 2D and 3D styles; symbols,
characters, and emoticons; in a mix of colours and
media, though maybe not all at the same time!

How crazy an effect you want is up to you, and your
experimenting will help you to learn what looks good
and the possibilities of what you can create. Have a
go for yourself and see what weird and wonderful
examples you can come up with.

ACKNOWLEDGEMENTS

Firstly, I would like to say a HUGE thank you to my boyfriend Rory Elphick for all his amazing help and support throughout the making of this book. I couldn't have done it without you! Thank you so much for all the help over the busy late nights, the dinners you made and the hundreds of cups of coffee!... and for being my number one fan!

I'd also like to give a special thanks to Caro Elphick for all her support during the making of this book. And of course a very big thank you to my sister Kerry Hughes, and my parents David and Rosemary Hughes.

Much love and thanks to all of my best friends who have given me their help and encouragement during the making of this book, checking my artworks and lessons to see if they made sense, and for putting up with me during busier times!... Generally being all round great people and inspiring me in one way or another.

And thank you to Elizabeth Dixon, Edward Spice, Wayne James, Zoë Moncaster, Brendon Blackaby, Rob Elliot and Simon Eves.

THE PUBLISHER WOULD ALSO LIKE TO THANK EVERYONE WHO HELPED WITH THIS BOOK, INCLUDING:

Lorenza Borz; Meri Paterson; Natalia Price-Cabrera; Stephanie Hetherington; Elena Tranbjerg Andersen; Bethan Reynolds; Roly Allen; Alla Miller; Dasha Miller; Sue Leung; Harumi Currie; Andrius Juknys; Sarah Vaughan; Siobhan McDermott; Ákos Nagy; Natasha Rao; Melanee Winder; Ross Calman; Kawaihuelani Center for Hawaiian Language, UH Mānoa;

Dr Kate Spence, Archaeology Division, University of Cambridge; Dr Cédric Gobeil, Director of the Egypt Exploration Society; Tracy Sims; Adam Juniper; Elisabeth Magin, Centre for the Study of the Viking Age, University of Nottingham; Magdalena Feldekova; Angela Mota Escudero; Jen Lindblad; Zara Anvari; Julie Weir; Rachel Silverlight; Elizabeth Varley; Valerie Ng; Frank Gallaugher; Rebekka Guðleifsdóttir; Rosie Taekama; Marlou Veltman; Sven Thierie.

Many thanks to everyone at Ilex for their impressive multilingual skills. Also a big thanks to Lesley Malkin and Ellie Wilson for their endless patience and excellent suggestions. And last but not least, thanks to Ginny Zeal and Sarah Kulasek-Boyd for making this book look as beautiful as it possibly can.

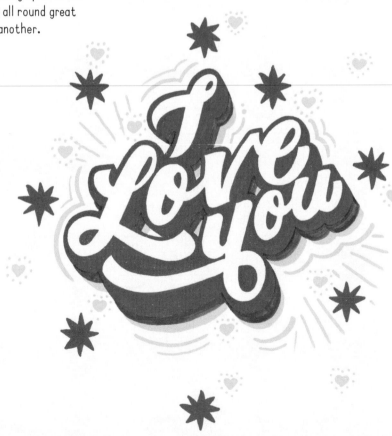